TRANSITIONS AND TRANSLATIONS

LINDA SACCOCCIO

ISBN 978-1-312-17579-2
Copyright © 2014 by Linda Saccoccio
All Rights Reserved

Editor, Josh Brayer
Designer, Tim Rossi
Group photo of grandparents, Helen Schiano
Solo Grandparents photo, Unknown Photographer
Author's photo, Barry Winick

Singing Swallows Productions

*When one has once had the good luck to love intensely,
life is spent trying to recapture that ardor and that illumination.*

-Albert Camus

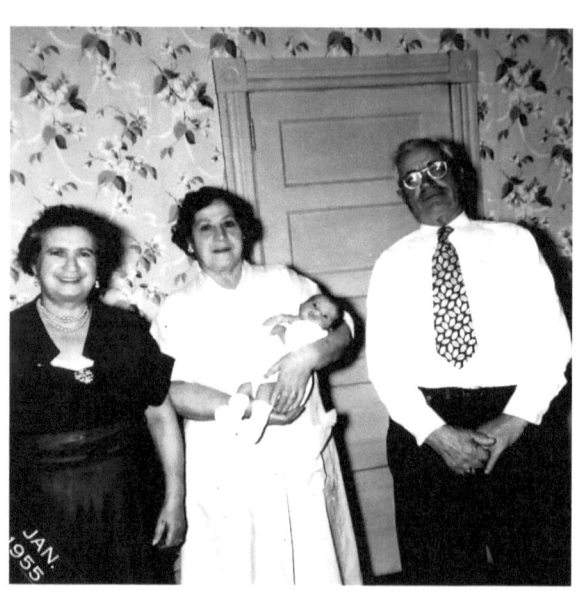 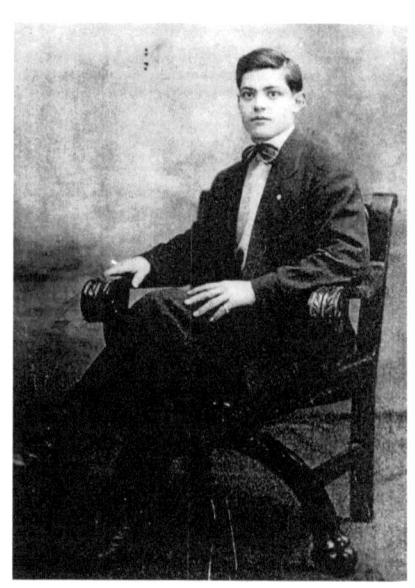

Dedicated to my grandparents from Italy

Celia Morgera Schiano

Ortensio Schiano

Lucia Stamegna Saccoccio

Domenico Saccoccio

Preface

There once was a One. This is a story we tell ourselves, that runs deep in our psyches, whether we speak of dividing the light from the dark, or of the Bigness banging. I like to think that the One had a choice to become more than one, that it chose to be two and more than two. I ask myself what could have tempted that One beyond its singularity, into where we are. What could have seduced it into a place of suffering, which does not, cannot exist within the One, where there is no separation. You might say Love drew it forth, out of its unity, but I cannot see that. The One is Love. It does not need to offer Love back to itself. What does the state of separation have to offer to a One who is, without it, Bliss, Eternity, Infinitude?

Only this: perception. The One cannot see itself; there is no place within it from which it might be seen. It cannot feel Love, or Bliss or Eternity. It can only be them. The One breaks itself open, to suffering, to us, for this: so that it might regard itself, so that it might regard us, so that we might regard.

Every brush of visible light, every pulse of sound, every caress of feeling is the One here for its purpose, for its Joy. If we could but know this at every sensation, we would tremble, we would perhaps even be driven mad by the miracle in which we are enmeshed. And yet, in our separation, we cannot know it, can only strive to see it, to inhabit this truth, little by little, and for brief moments.

Those who make this light, that color, those words or sounds new to us, all over again, they are holy. They open up the door that leads back from us to the One, and that leads from the One towards us, towards its purpose. They are here to help us remember why we are here.

Linda Saccoccio is one of those Holy Ones. She and I have never spoken a word about any of this, and yet I know that is true. I know it because when I look at her paintings and read her words, I begin to remember why we are here. Yes, they are beautiful, yes, they are thoughtful, and exquisitely crafted, and everything my rational mind would want them to be. But what matters is how the beauty and thought and craft open us up to what is Beyond, to Remembrance, to Love.

Look. Read. Remember.

Beth Taylor Schott, Author

Introducing Ekphrasis

When colors, gestures, lines and space come together, they evoke feelings. This occurs without the need of cognitive comprehension. Visual art communicates with immediacy. When we read what is articulated through words on a page, we think and then process. With visual art, there is an immediate impression at the onset of seeing it. That said, when poets stand before a work of art, a world of sensation opens up to them, and if they continue with the experience, a variety of ideas and narratives may surface. Poetry is a mix between the immediate and the cognitive. The ping of the sound of a word can awaken deeply rooted memories or ideas, and then the words direct and suggest meanings. The response of poets to a work of art can be as diverse and unique as a thumbprint. Poems that arise from viewing art, add a new, imaginative layer that may be surprising, even to the artist who created the work. Ekphrastic poetry pays homage to art, adding the gift of individual reflection, opening yet another door of experience and adventure.

Linda Saccoccio

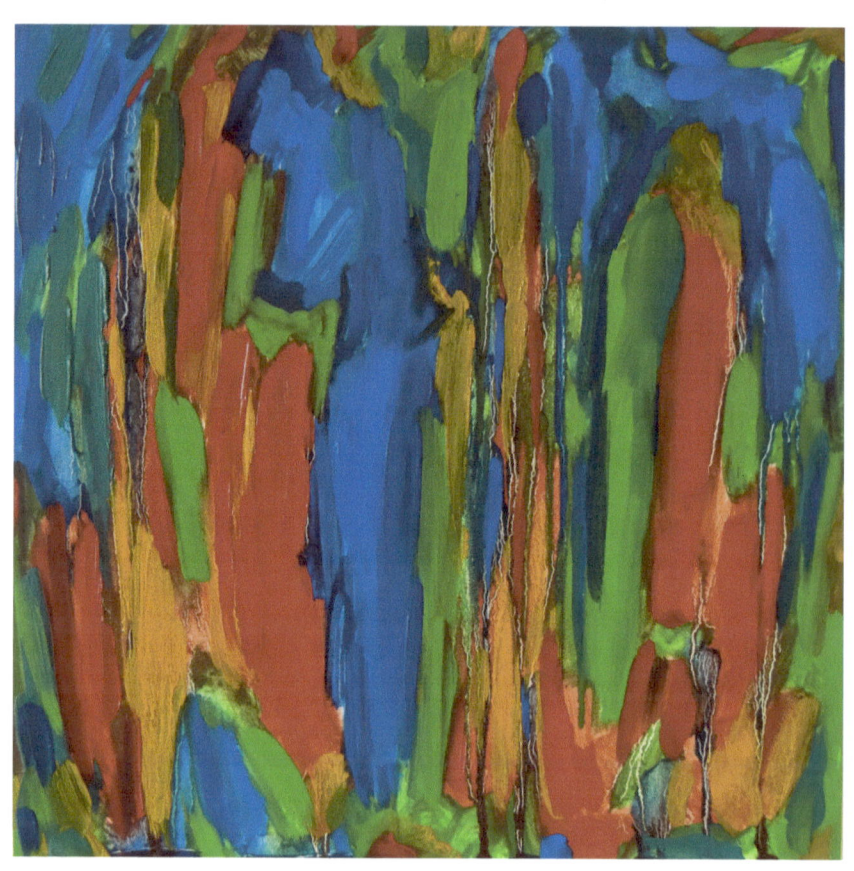

Ancient Present
Oil on Canvas
12" x 12"

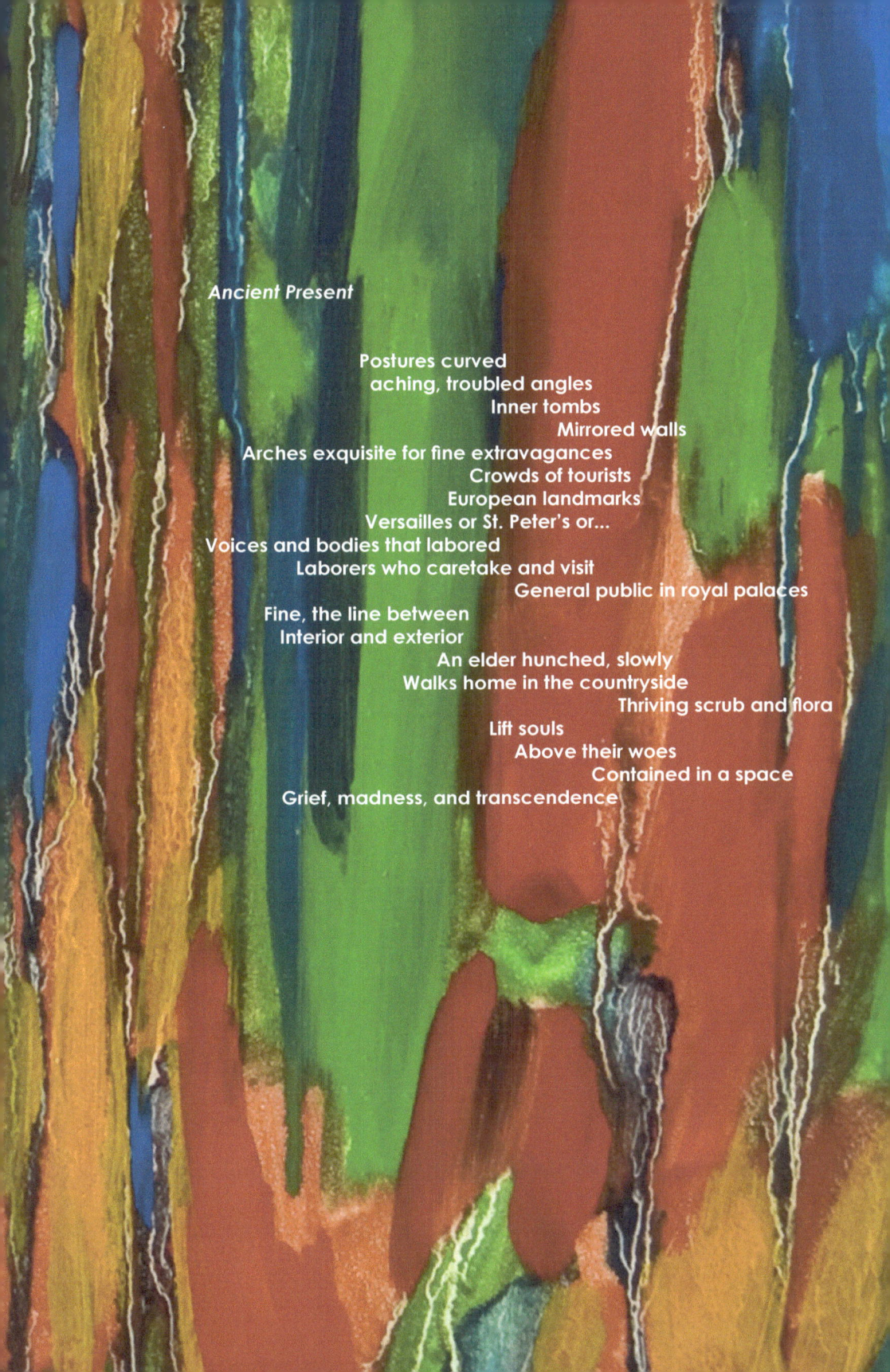

Ancient Present

Postures curved
aching, troubled angles
Inner tombs
Mirrored walls
Arches exquisite for fine extravagances
Crowds of tourists
European landmarks
Versailles or St. Peter's or…
Voices and bodies that labored
Laborers who caretake and visit
General public in royal palaces
Fine, the line between
Interior and exterior
An elder hunched, slowly
Walks home in the countryside
Thriving scrub and flora
Lift souls
Above their woes
Contained in a space
Grief, madness, and transcendence

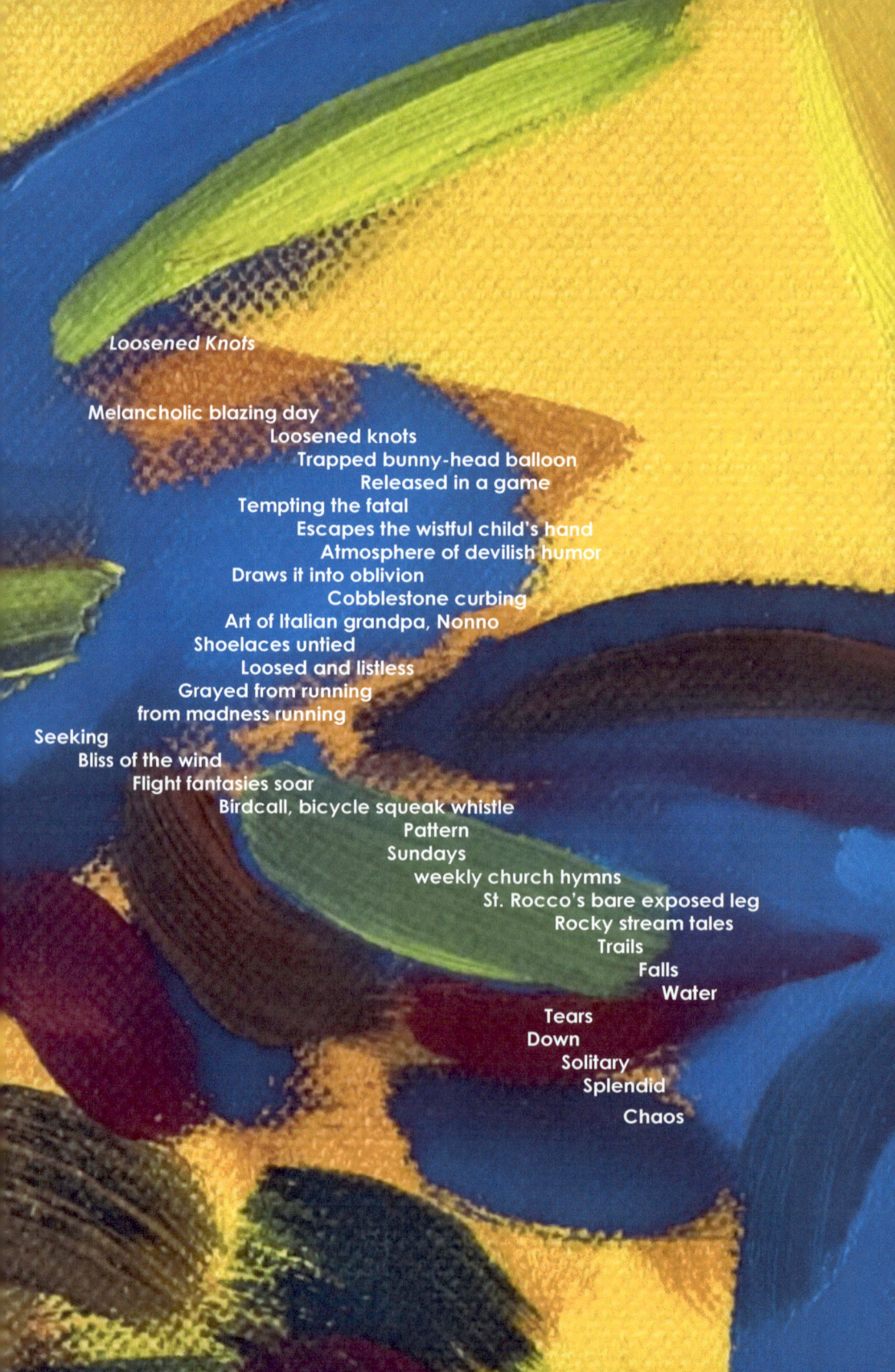

Loosened Knots

Melancholic blazing day
 Loosened knots
 Trapped bunny-head balloon
 Released in a game
 Tempting the fatal
 Escapes the wistful child's hand
 Atmosphere of devilish humor
 Draws it into oblivion
 Cobblestone curbing
 Art of Italian grandpa, Nonno
 Shoelaces untied
 Loosed and listless
 Grayed from running
 from madness running
Seeking
 Bliss of the wind
 Flight fantasies soar
 Birdcall, bicycle squeak whistle
 Pattern
 Sundays
 weekly church hymns
 St. Rocco's bare exposed leg
 Rocky stream tales
 Trails
 Falls
 Water
 Tears
 Down
 Solitary
 Splendid
 Chaos

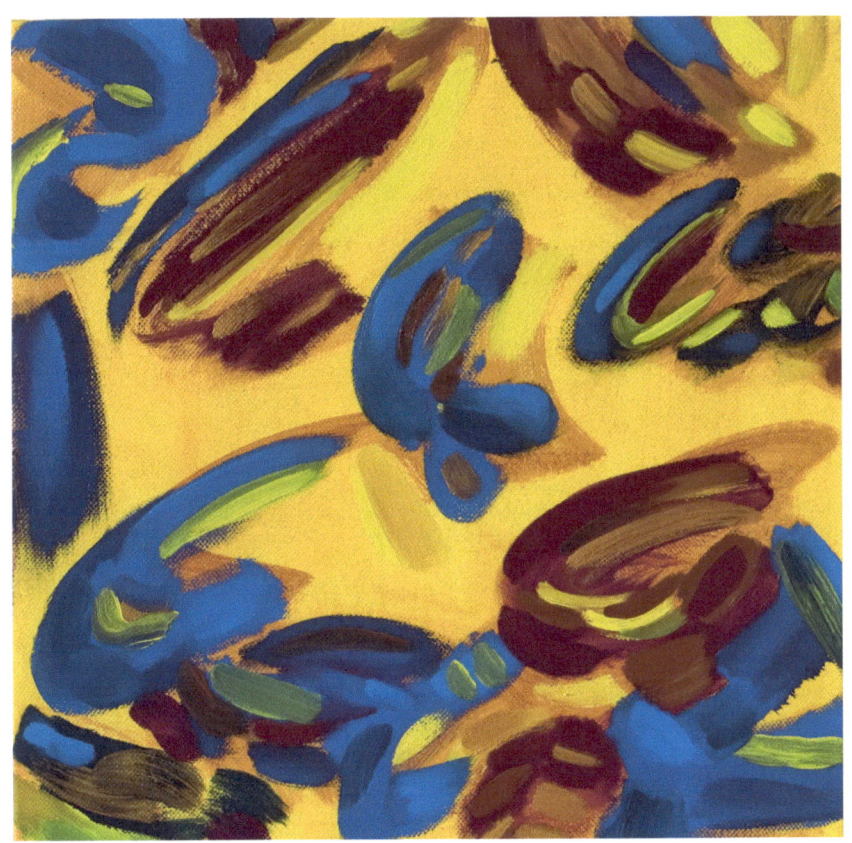

Loosened Knots
Oil on Canvas
12" x 12"

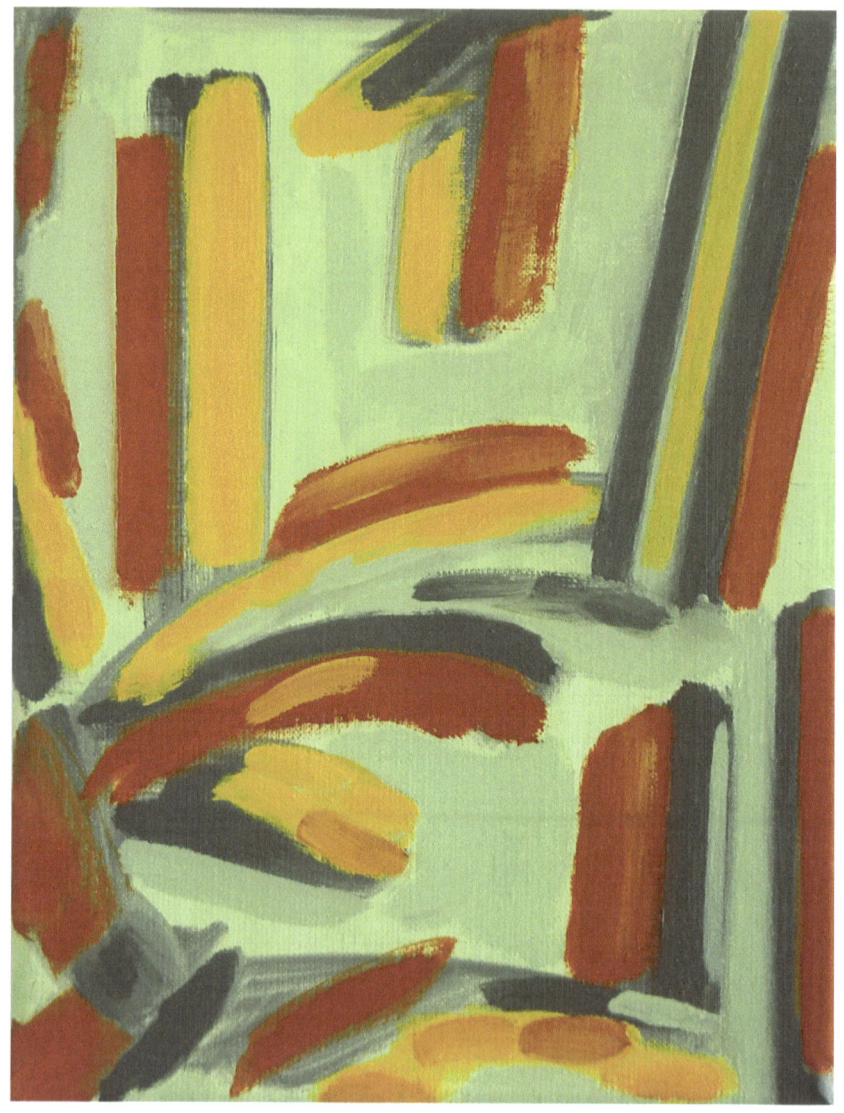

Gleaning Home from NYC
Oil on Canvas
9" x 12"

Gleaning Home from NYC

Straight, forward
In wavering water
Salted and plain,
Rippling, monotonous buildings
On an island of granite bedrock
Your root sensibility
Crawling through the streets
Calling from, injured flesh
Nourished in shared alienation
A holding pattern for
A diehard libertarian
In shadows and narrow passageways
Possibility seeps from acrid air
Meditation on the menu of cavernous avenues
Regular patterns cradle
Step over step
Breath by breath
Witnessing This
Dissolving the stickiness of
ties
Sweetbrier pierces the heart
Collar and leash twisted
Wrapped around your neck
In familial closets
Through a crack in the door
Eastern sun disables
Caustic thought
Gleaning home

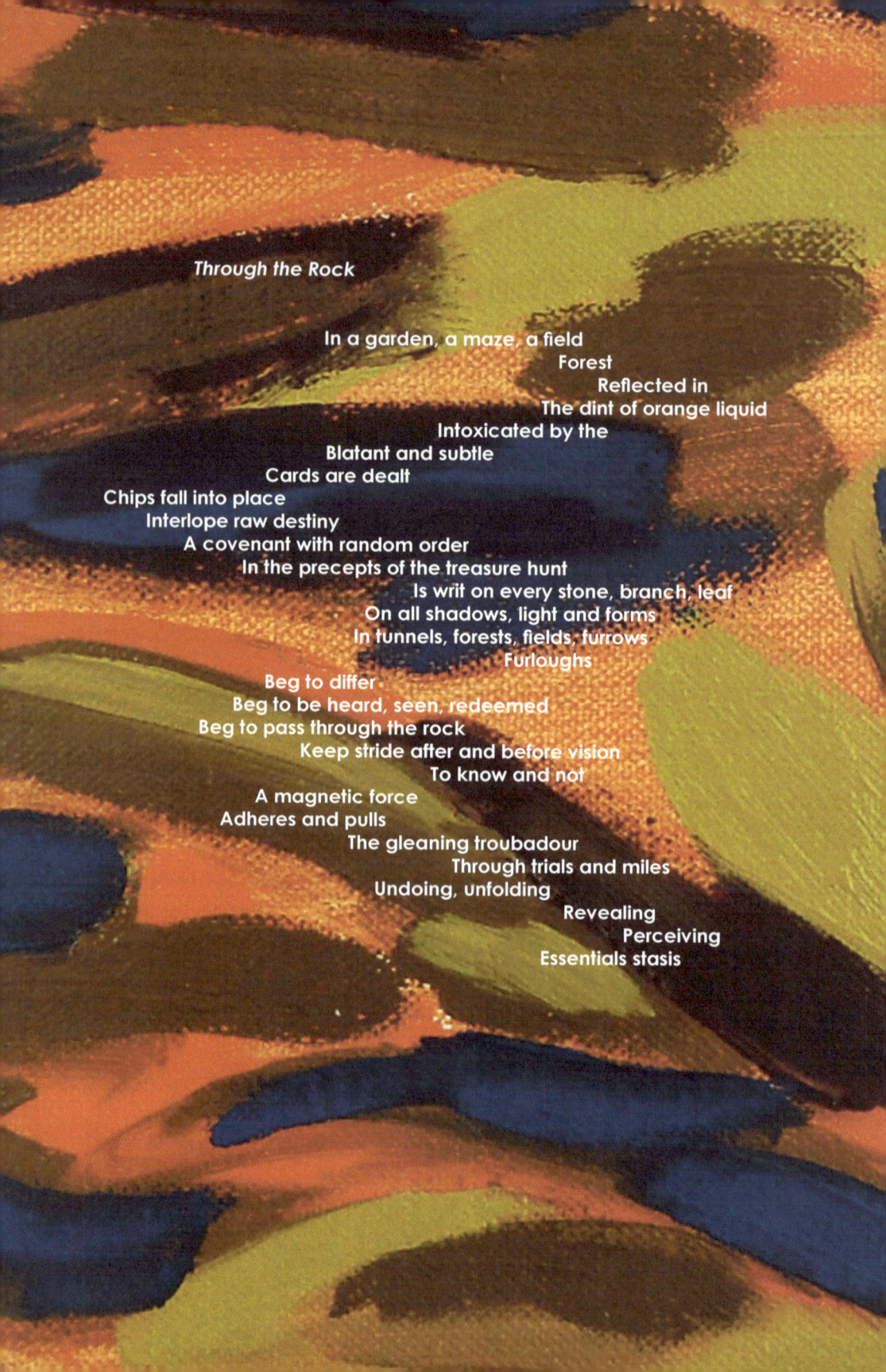

Through the Rock

In a garden, a maze, a field
Forest
Reflected in
The dint of orange liquid
Intoxicated by the
Blatant and subtle
Cards are dealt
Chips fall into place
Interlope raw destiny
A covenant with random order
In the precepts of the treasure hunt
Is writ on every stone, branch, leaf
On all shadows, light and forms
In tunnels, forests, fields, furrows
Furloughs
Beg to differ
Beg to be heard, seen, redeemed
Beg to pass through the rock
Keep stride after and before vision
To know and not
A magnetic force
Adheres and pulls
The gleaning troubadour
Through trials and miles
Undoing, unfolding
Revealing
Perceiving
Essentials stasis

Through the Rock
Oil on Canvas
12" x 12"

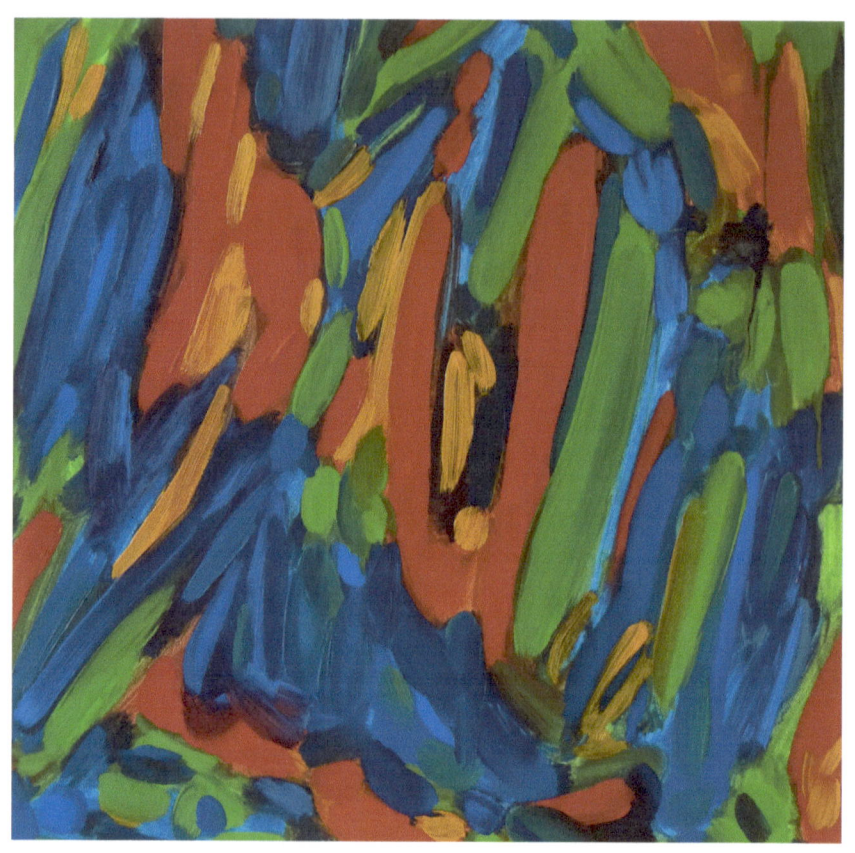

Cascading Emerald Blues
Oil on Canvas
12" x 12"

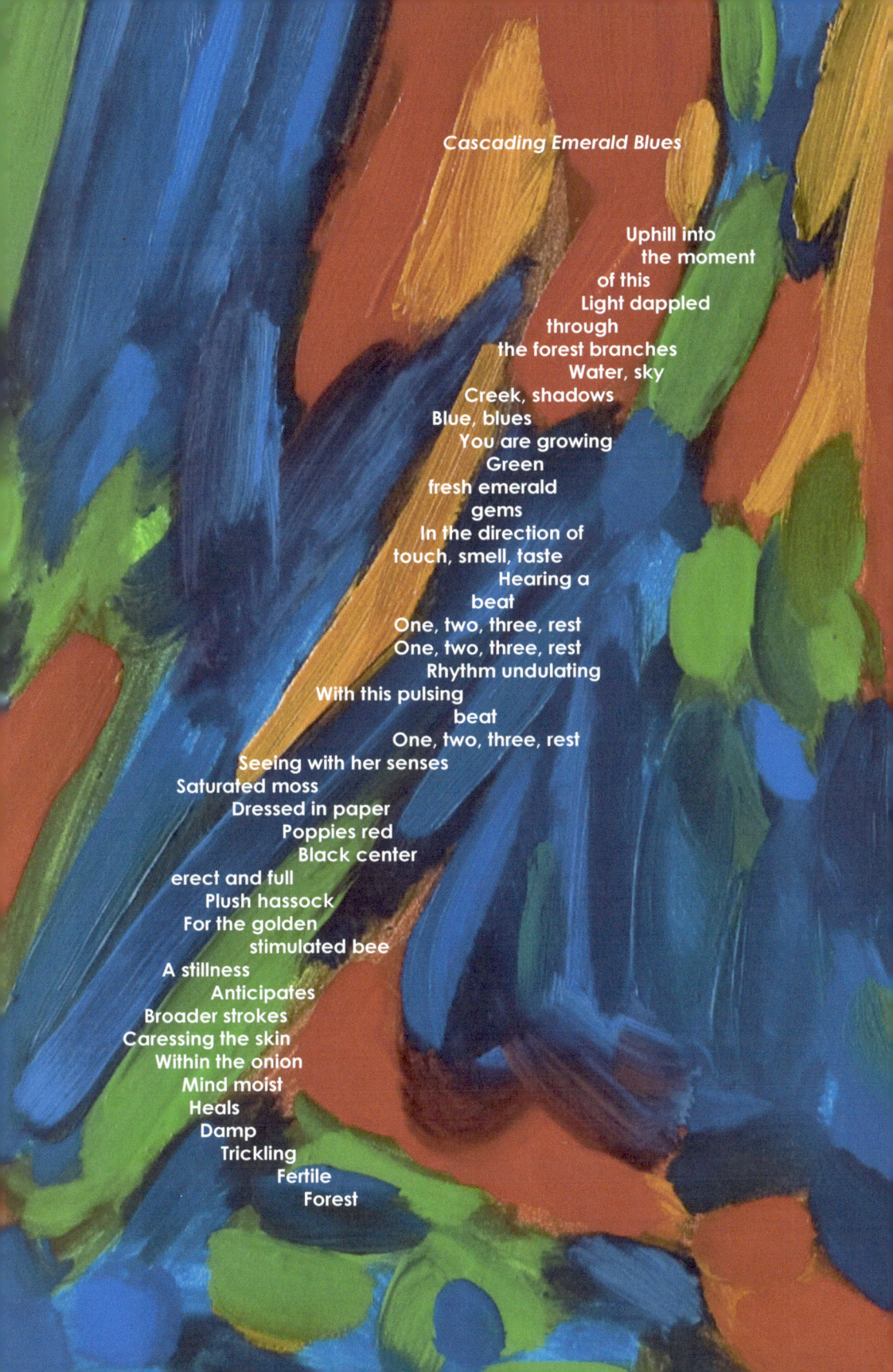

Cascading Emerald Blues

Uphill into
the moment
of this
Light dappled
through
the forest branches
Water, sky
Creek, shadows
Blue, blues
You are growing
Green
fresh emerald
gems
In the direction of
touch, smell, taste
Hearing a
beat
One, two, three, rest
One, two, three, rest
Rhythm undulating
With this pulsing
beat
One, two, three, rest
Seeing with her senses
Saturated moss
Dressed in paper
Poppies red
Black center
erect and full
Plush hassock
For the golden
stimulated bee
A stillness
Anticipates
Broader strokes
Caressing the skin
Within the onion
Mind moist
Heals
Damp
Trickling
Fertile
Forest

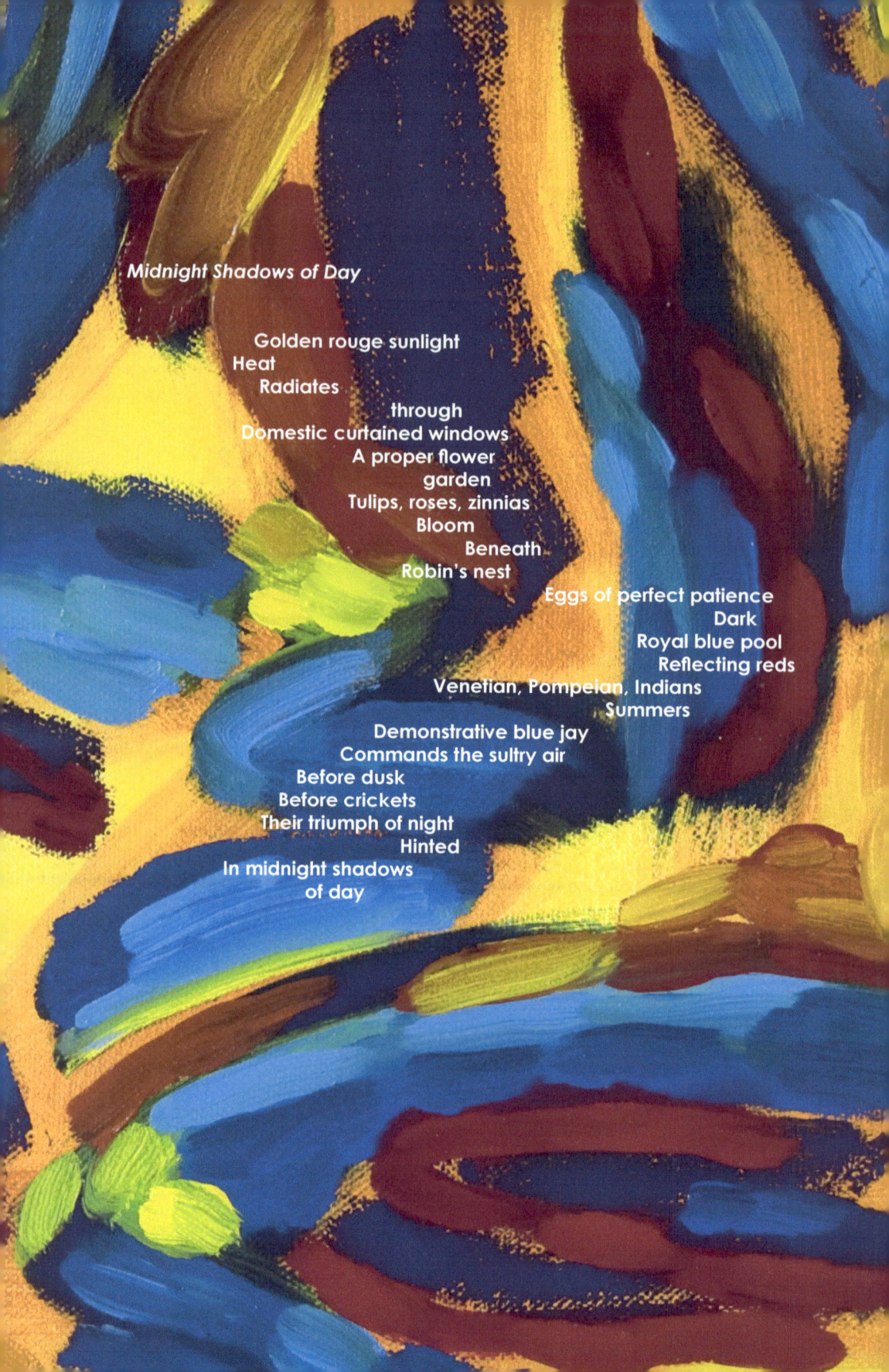

Midnight Shadows of Day

Golden rouge sunlight
Heat
Radiates
through
Domestic curtained windows
A proper flower
garden
Tulips, roses, zinnias
Bloom
Beneath
Robin's nest
Eggs of perfect patience
Dark
Royal blue pool
Reflecting reds
Venetian, Pompeian, Indians
Summers
Demonstrative blue jay
Commands the sultry air
Before dusk
Before crickets
Their triumph of night
Hinted
In midnight shadows
of day

Midnight Shadows of Day
Oil on Canvas
12" x 12"

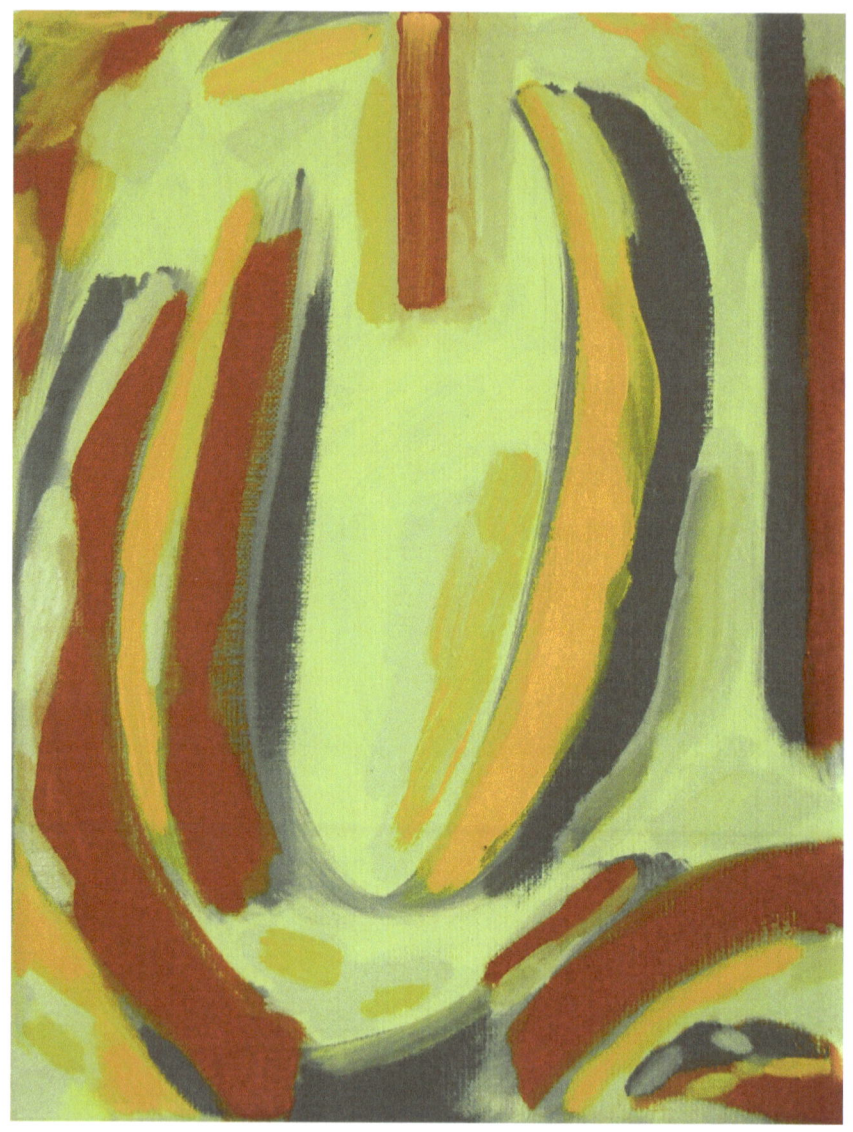

Eve
Oil on Canvas
9" x 12"

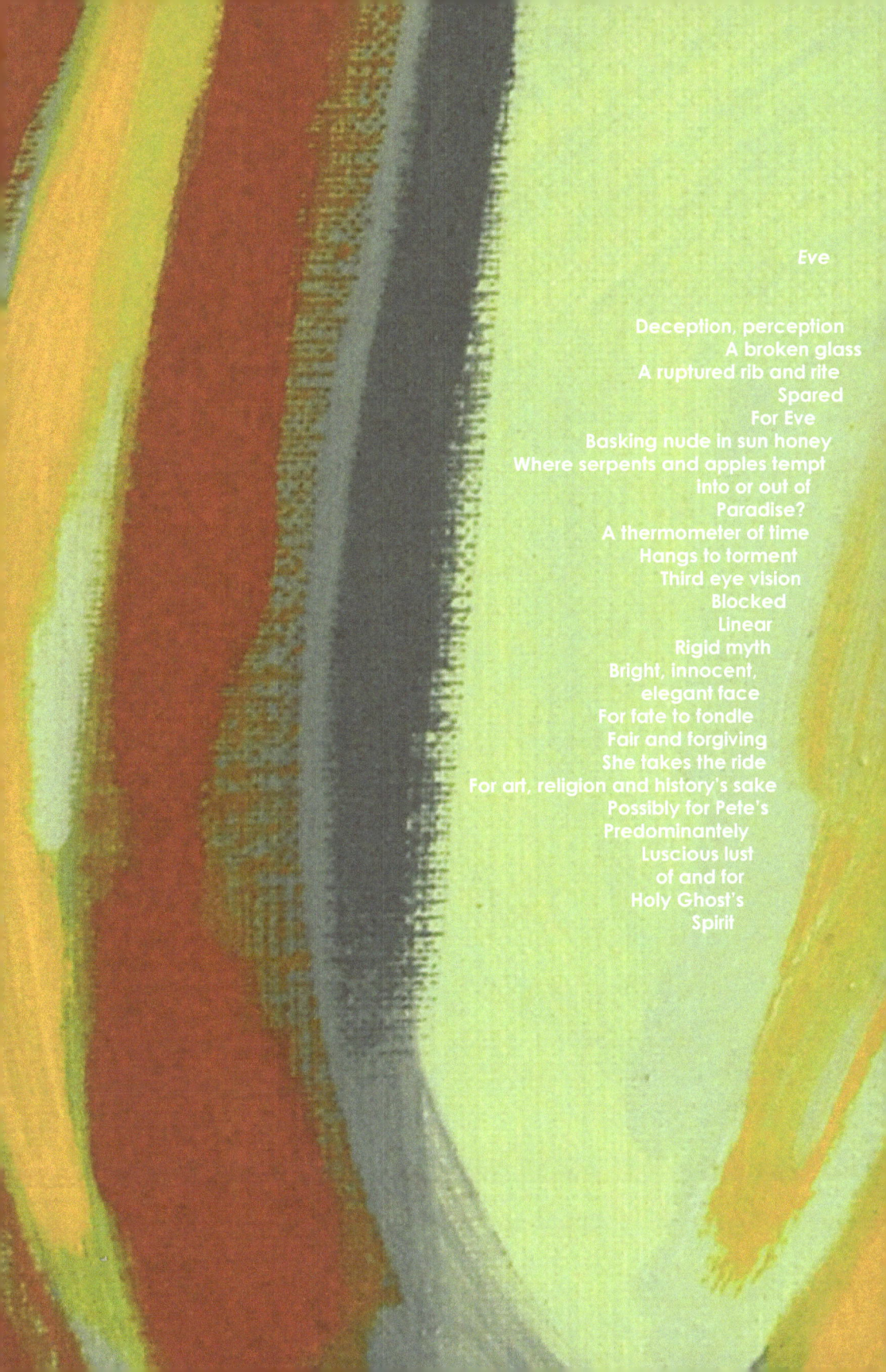

Eve

Deception, perception
A broken glass
A ruptured rib and rite
Spared
For Eve
Basking nude in sun honey
Where serpents and apples tempt
into or out of
Paradise?
A thermometer of time
Hangs to torment
Third eye vision
Blocked
Linear
Rigid myth
Bright, innocent,
elegant face
For fate to fondle
Fair and forgiving
She takes the ride
For art, religion and history's sake
Possibly for Pete's
Predominantely
Luscious lust
of and for
Holy Ghost's
Spirit

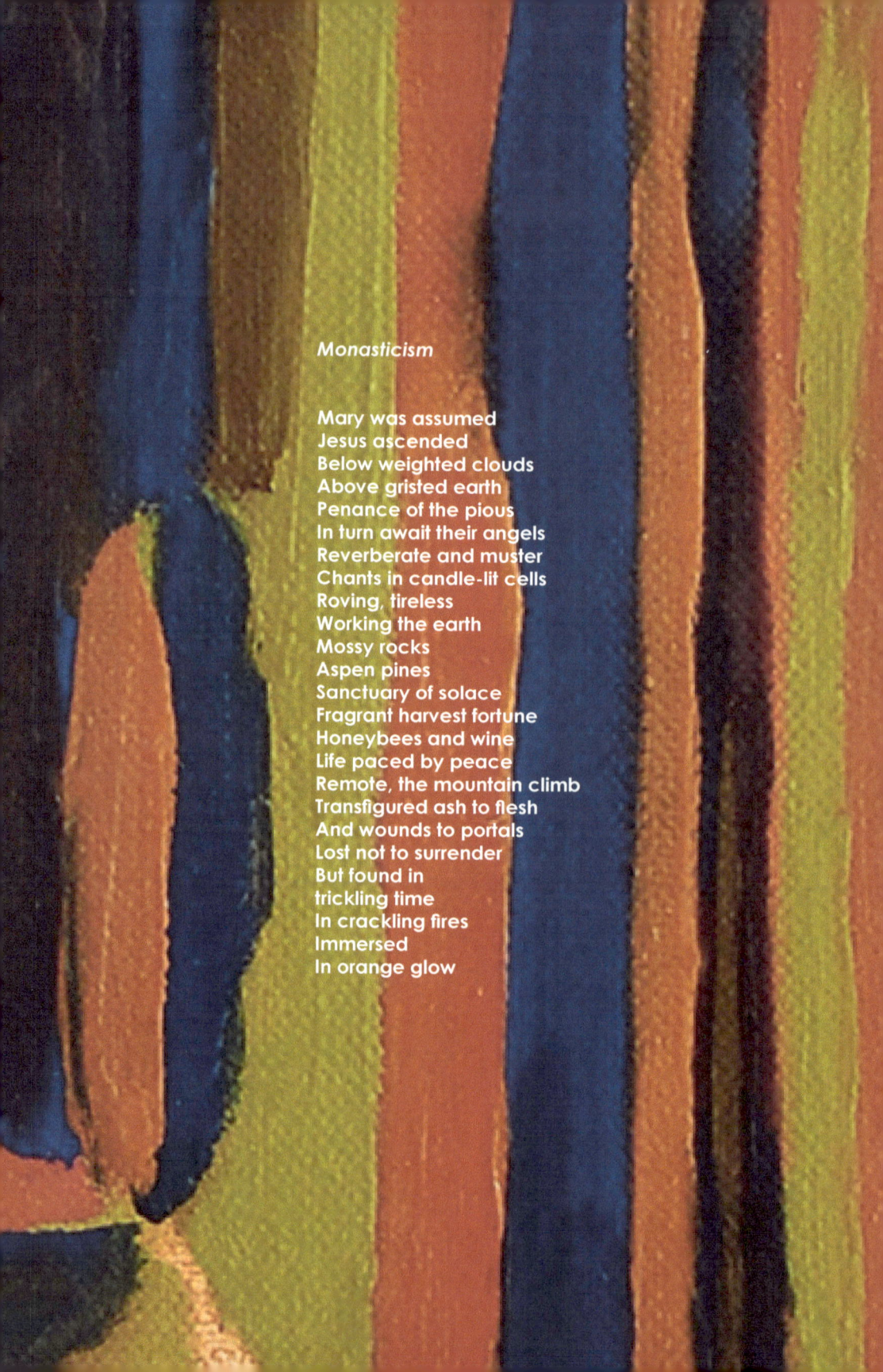

Monasticism

Mary was assumed
Jesus ascended
Below weighted clouds
Above gristed earth
Penance of the pious
In turn await their angels
Reverberate and muster
Chants in candle-lit cells
Roving, tireless
Working the earth
Mossy rocks
Aspen pines
Sanctuary of solace
Fragrant harvest fortune
Honeybees and wine
Life paced by peace
Remote, the mountain climb
Transfigured ash to flesh
And wounds to portals
Lost not to surrender
But found in
trickling time
In crackling fires
Immersed
In orange glow

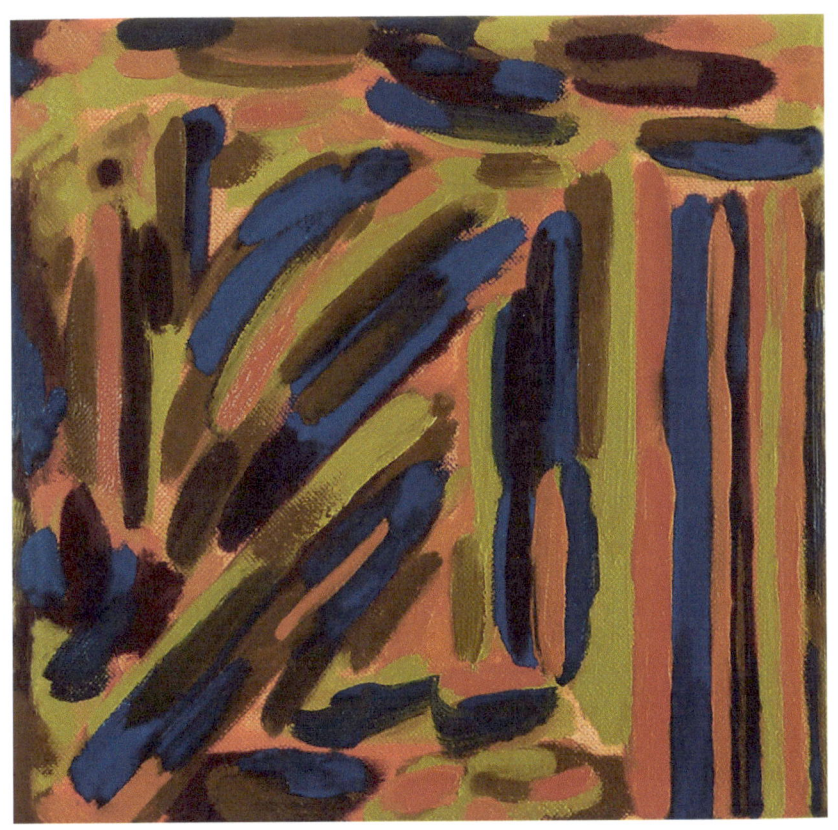

Monasticism
Oil on Canvas
12" x 12"

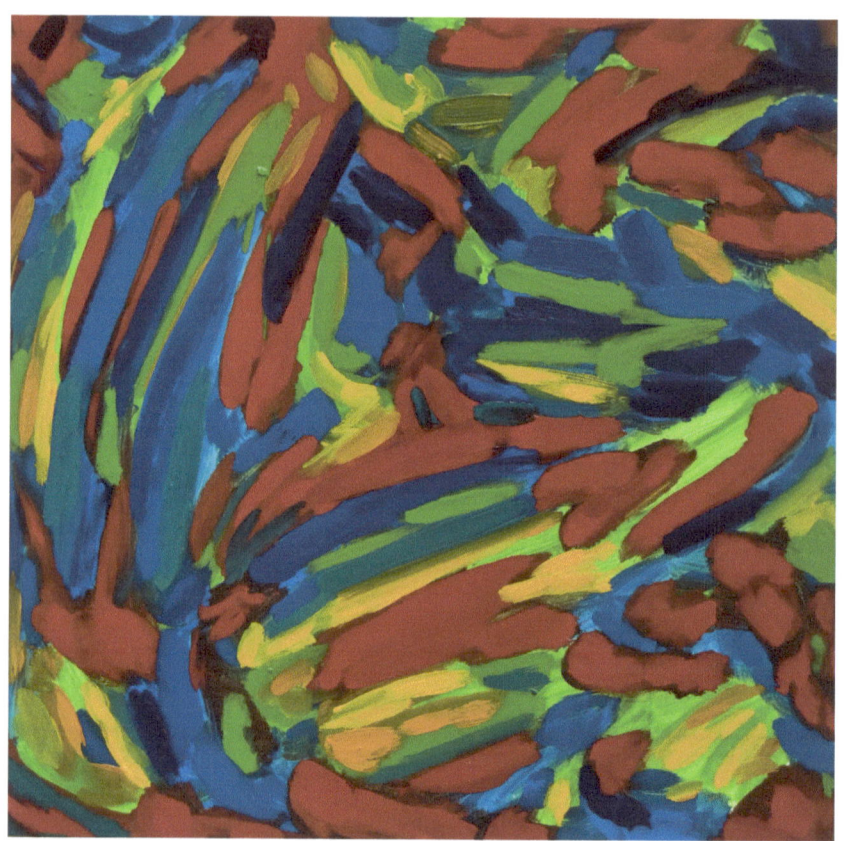

Treasure Trove
Oil on Canvas
12" x 12"

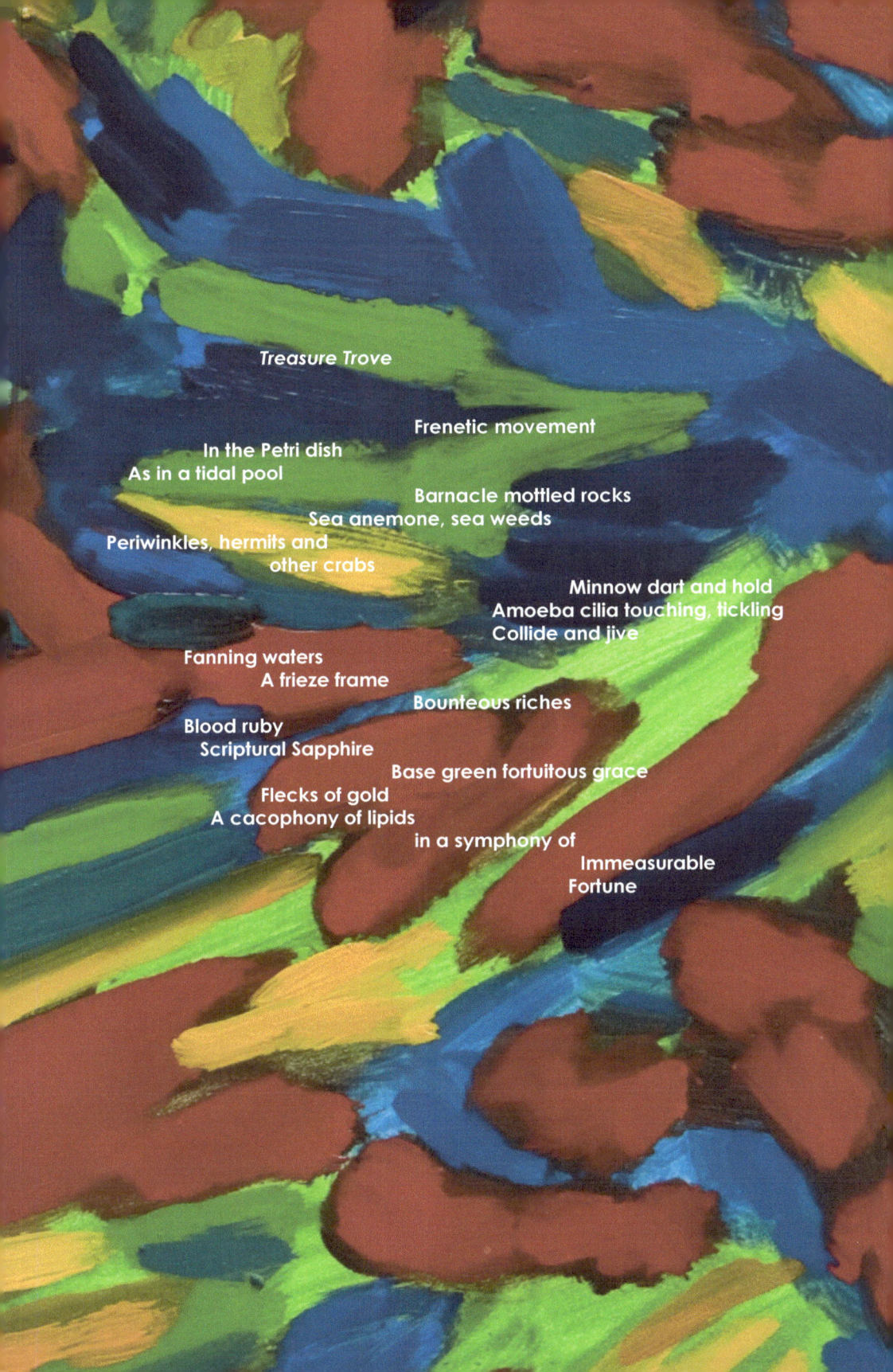

Treasure Trove

Frenetic movement
In the Petri dish
As in a tidal pool
Barnacle mottled rocks
Sea anemone, sea weeds
Periwinkles, hermits and
 other crabs
Minnow dart and hold
Amoeba cilia touching, tickling
Collide and jive
Fanning waters
A frieze frame
Bounteous riches
Blood ruby
Scriptural Sapphire
Base green fortuitous grace
Flecks of gold
A cacophony of lipids
in a symphony of
Immeasurable
Fortune

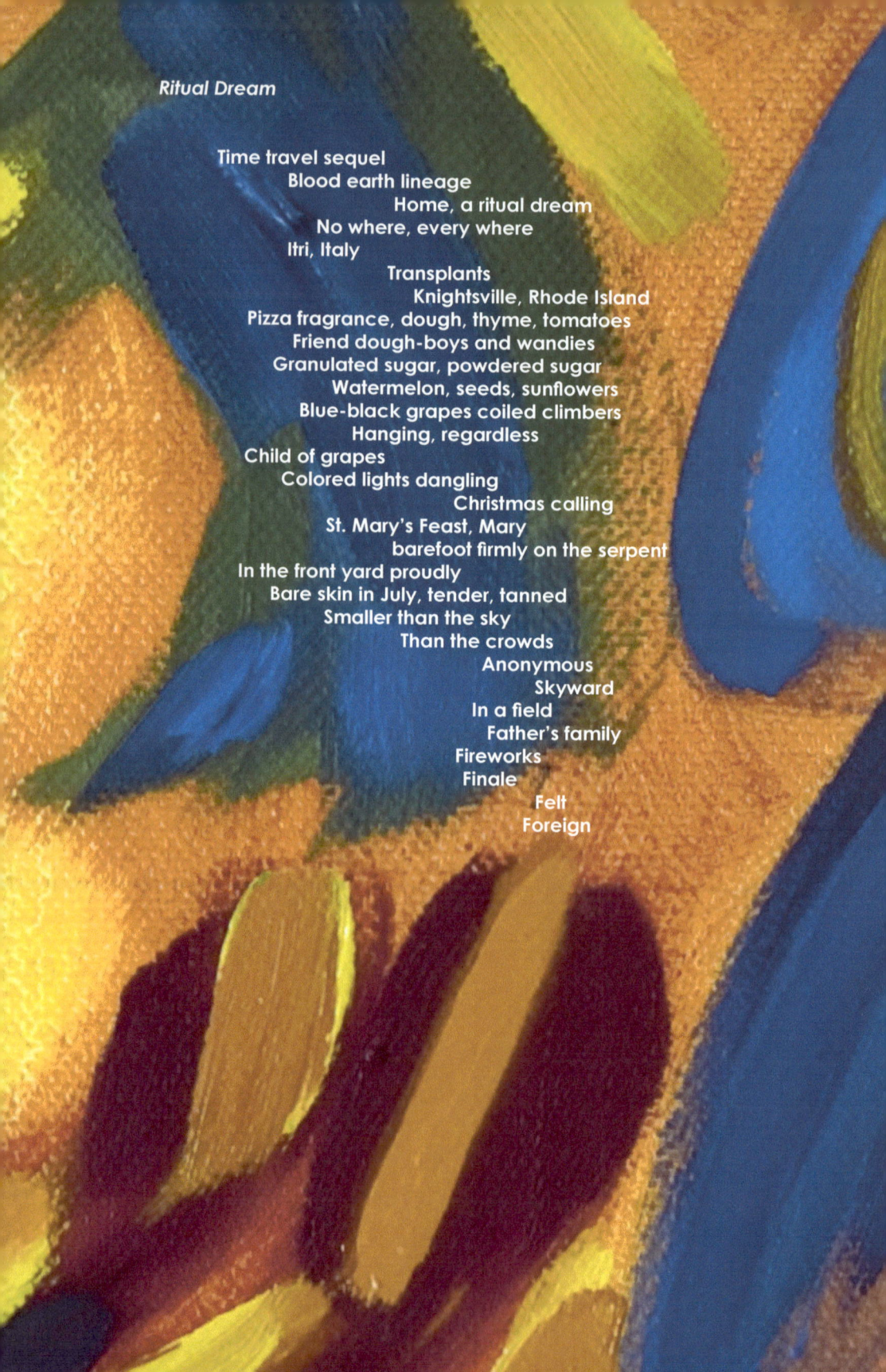

Ritual Dream

Time travel sequel
Blood earth lineage
Home, a ritual dream
No where, every where
Itri, Italy
Transplants
Knightsville, Rhode Island
Pizza fragrance, dough, thyme, tomatoes
Friend dough-boys and wandies
Granulated sugar, powdered sugar
Watermelon, seeds, sunflowers
Blue-black grapes coiled climbers
Hanging, regardless
Child of grapes
Colored lights dangling
Christmas calling
St. Mary's Feast, Mary
barefoot firmly on the serpent
In the front yard proudly
Bare skin in July, tender, tanned
Smaller than the sky
Than the crowds
Anonymous
Skyward
In a field
Father's family
Fireworks
Finale
Felt
Foreign

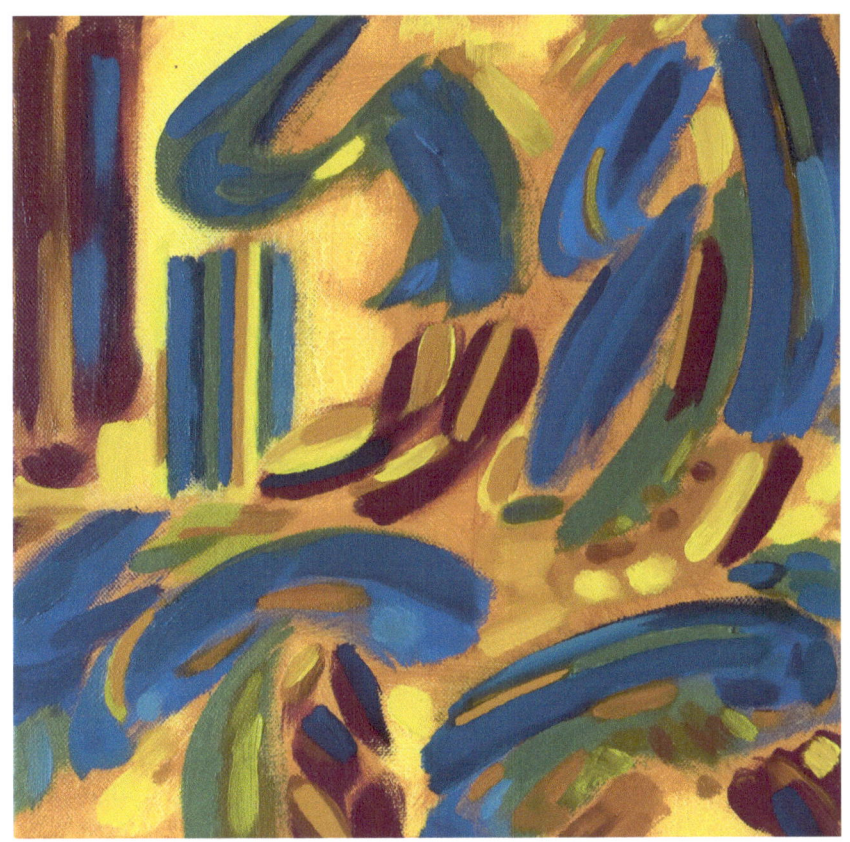

Ritual Dream
Oil on Canvas
12" x 12"

Strolling
Oil on Canvas
9" x 12"

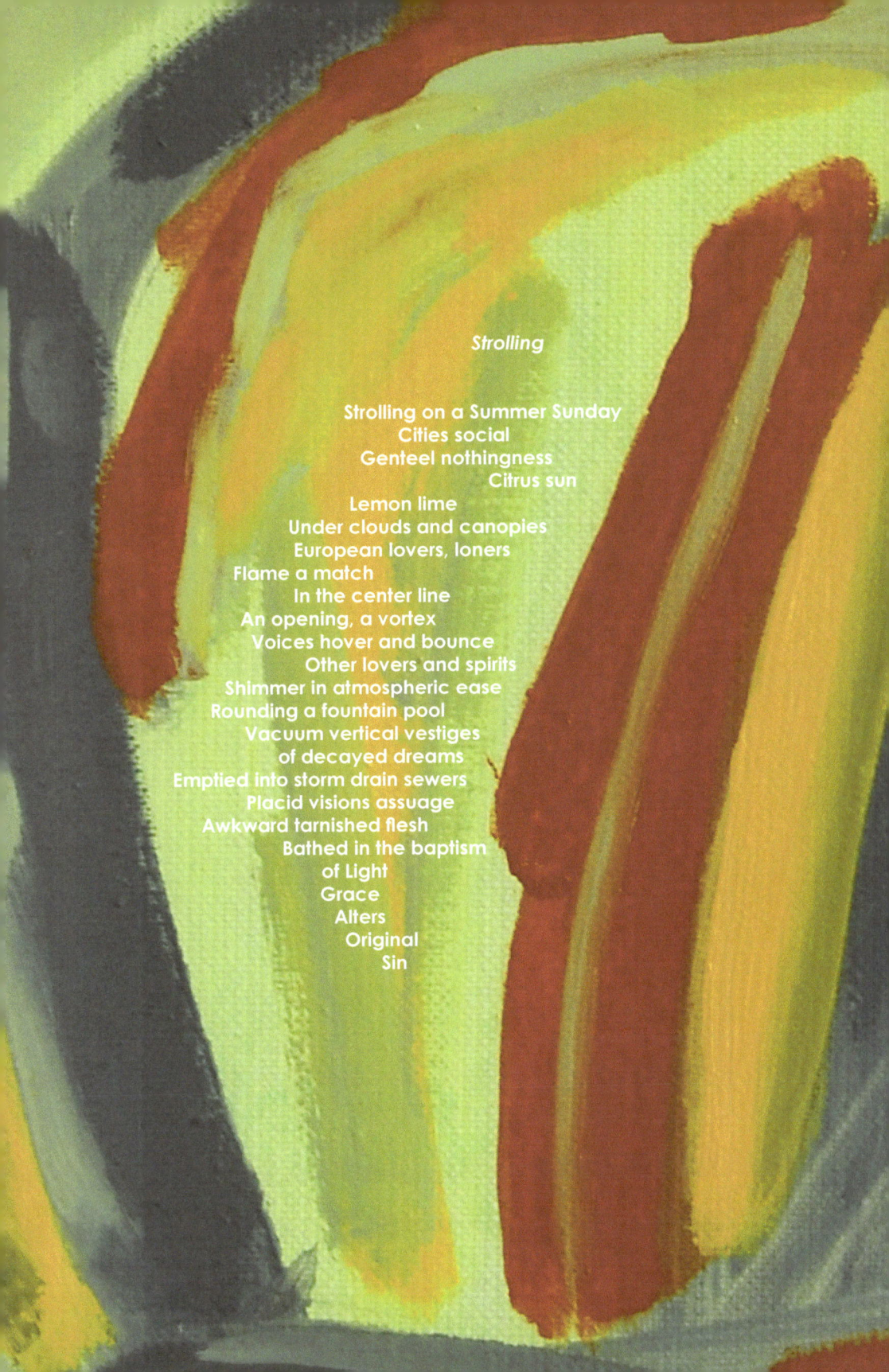

Strolling

Strolling on a Summer Sunday
Cities social
Genteel nothingness
Citrus sun
Lemon lime
Under clouds and canopies
European lovers, loners
Flame a match
In the center line
An opening, a vortex
Voices hover and bounce
Other lovers and spirits
Shimmer in atmospheric ease
Rounding a fountain pool
Vacuum vertical vestiges
of decayed dreams
Emptied into storm drain sewers
Placid visions assuage
Awkward tarnished flesh
Bathed in the baptism
of Light
Grace
Alters
Original
Sin

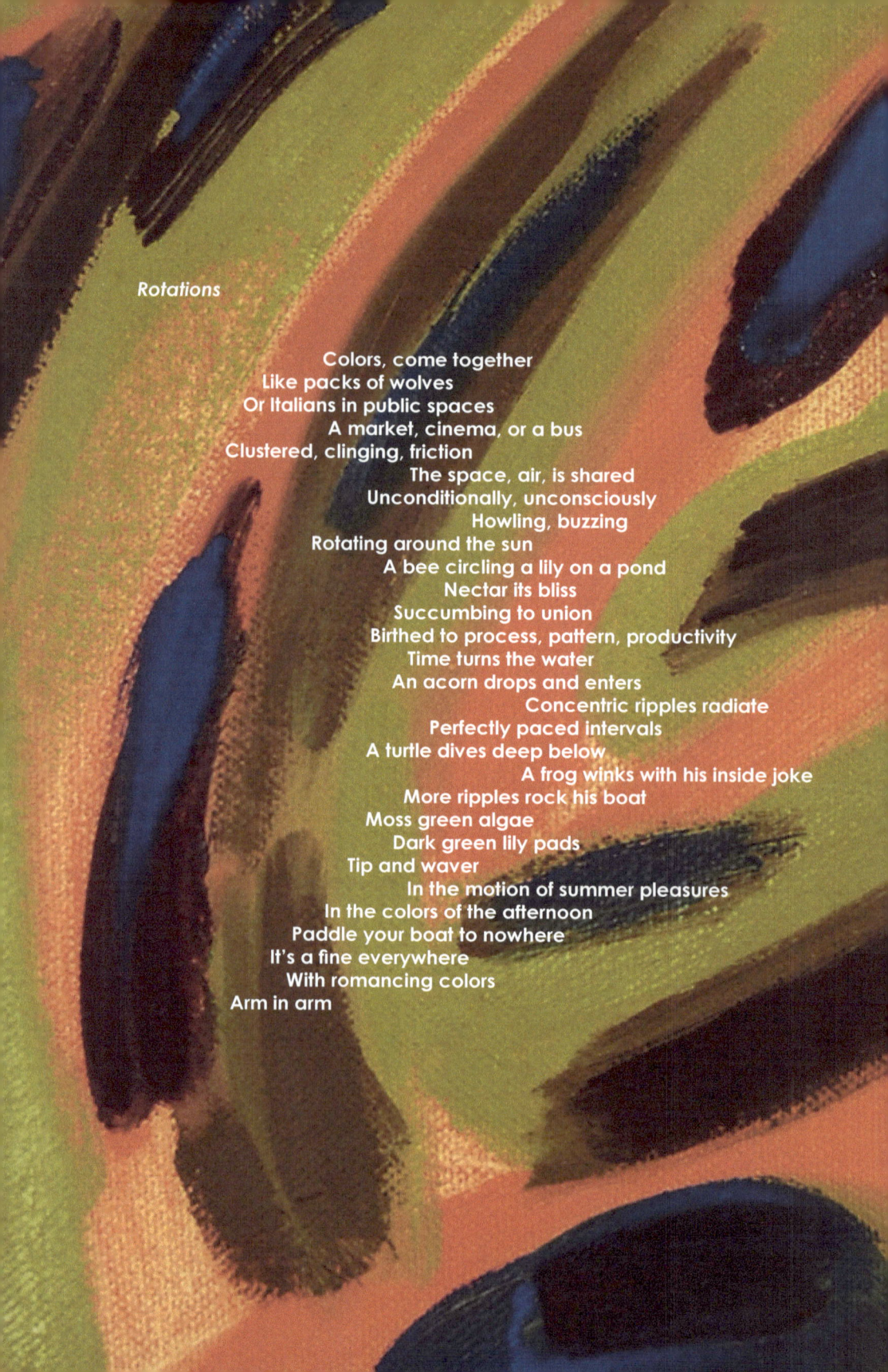

Rotations

Colors, come together
Like packs of wolves
Or Italians in public spaces
A market, cinema, or a bus
Clustered, clinging, friction
The space, air, is shared
Unconditionally, unconsciously
Howling, buzzing
Rotating around the sun
A bee circling a lily on a pond
Nectar its bliss
Succumbing to union
Birthed to process, pattern, productivity
Time turns the water
An acorn drops and enters
Concentric ripples radiate
Perfectly paced intervals
A turtle dives deep below
A frog winks with his inside joke
More ripples rock his boat
Moss green algae
Dark green lily pads
Tip and waver
In the motion of summer pleasures
In the colors of the afternoon
Paddle your boat to nowhere
It's a fine everywhere
With romancing colors
Arm in arm

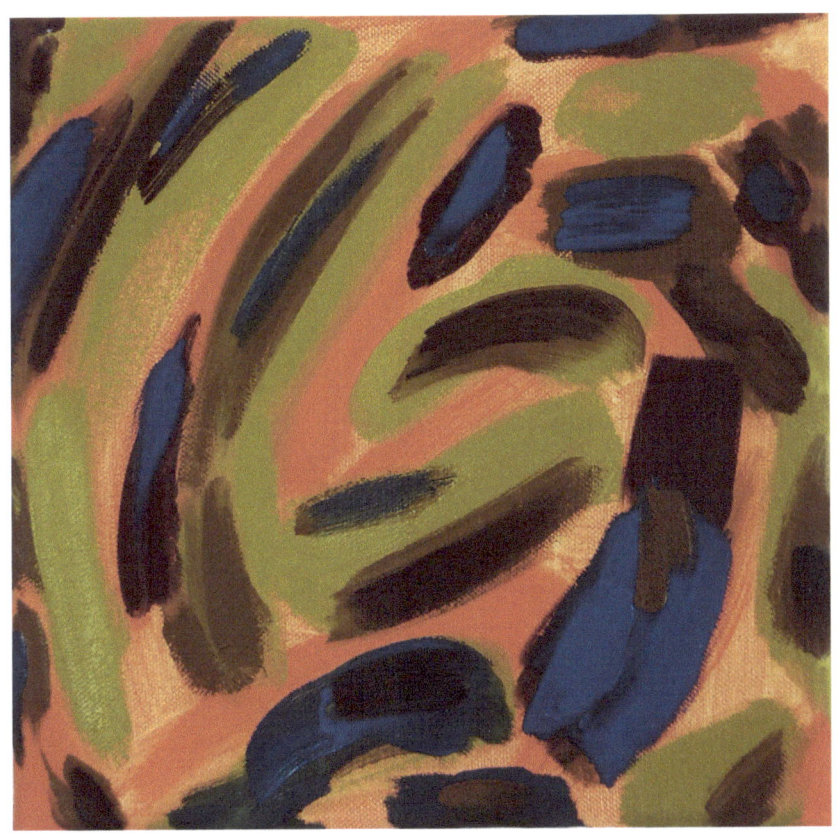

Rotations
Oil on Canvas
12" x 12"

With Thanks and Appreciation

To Anne Waldman and the
Summer Writing Program at Naropa University

All the faculty
Especially Sherwin Bitsui whose workshop guided the process of
writing the poems

Thanks to my artistic daughters:

Vani Alana Saccoccio Winick
Mira Saccoccio Winick

They inspire my voice in paint and words.

 Saccoccio's work bridges an ideological, practical, and contextual gap between East and West. Her brushwork embodies the aura of abstract expressionist and color field painters, while also evoking the spiritual practices of the Zen artist. In her approach to the blank canvas, Saccoccio taps into an ethereal source through silence, patience, and a willingness to be guided by a divine energy while trusting her own intuition. Saccoccio draws on all of her experiences and passions to create paintings that have both orderly and random qualities that form dialogues conveyed through a language of gestures.

Saccoccio's painting has evolved since leaving the dense and linear environment of New York City, where she worked as a painter and attended graduate school at the School of Visual Arts. Now, amidst the expansive beauty of Santa Barbara - with its subtle qualities of light and atmosphere, and its brilliant and earthy colors - her visual vocabulary has irreversibly changed and expanded. She is inspired by her surroundings, whether hiking in the foothills, walking on the beach, or viewing the Channel Islands and Pacific Ocean from her home. Her work continues to hold active tension through dialogue and relationship, in color, line and space with movement toward resolution, while inviting viewers to engage from their perspectives.

www.ingramcontent.com/pod-product-compliance
Lightning Source LLC
Chambersburg PA
CBHW041117180526
45172CB00001B/294